Color My Mandalas

LOUISE ATHERTON

COLOR MY MANDALAS

2017 Louise Atherton

ISBN: 1544899998
ISBN-13: 978-1544899992

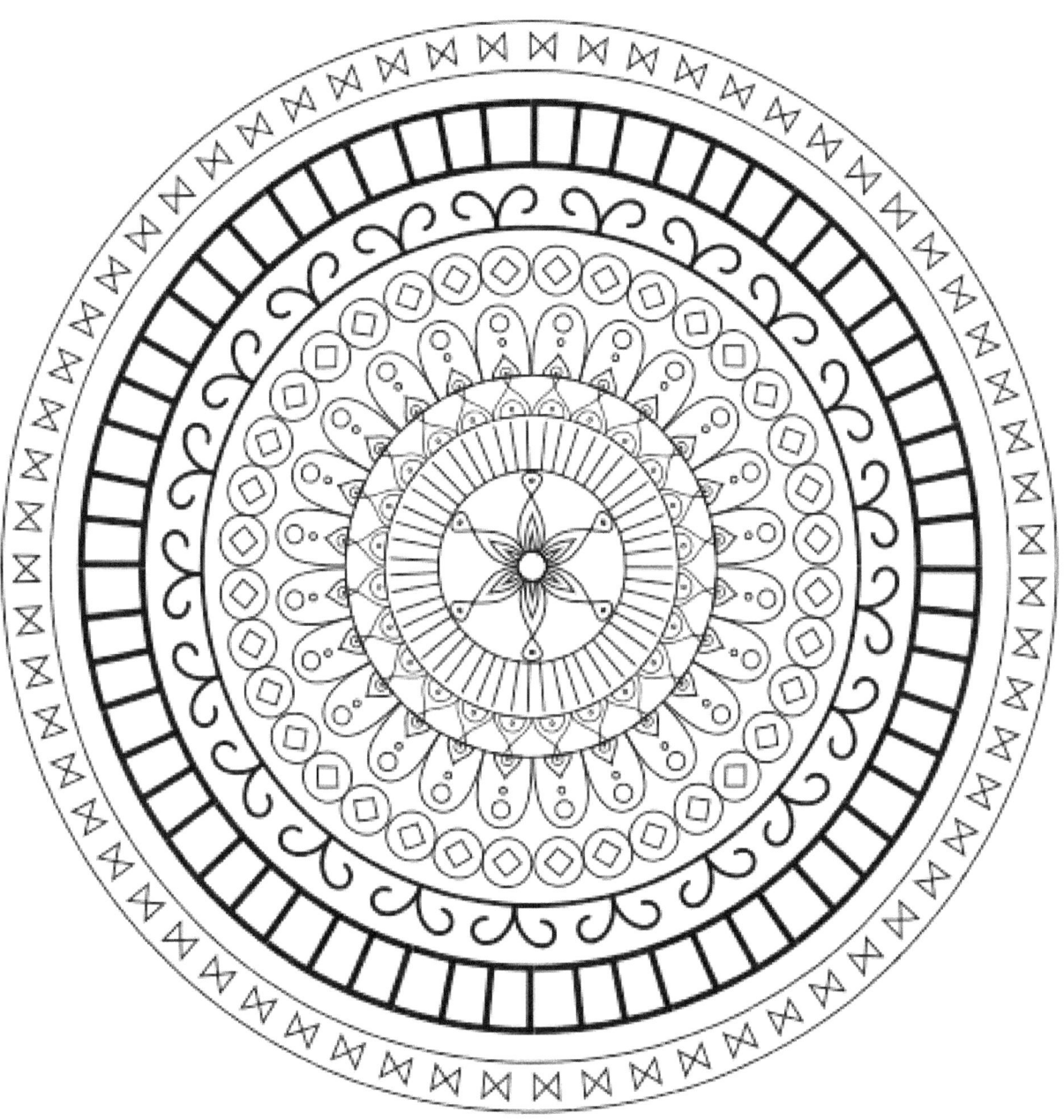

LOUISE ATHERTON

tranquility

COLOR MY MANDALAS

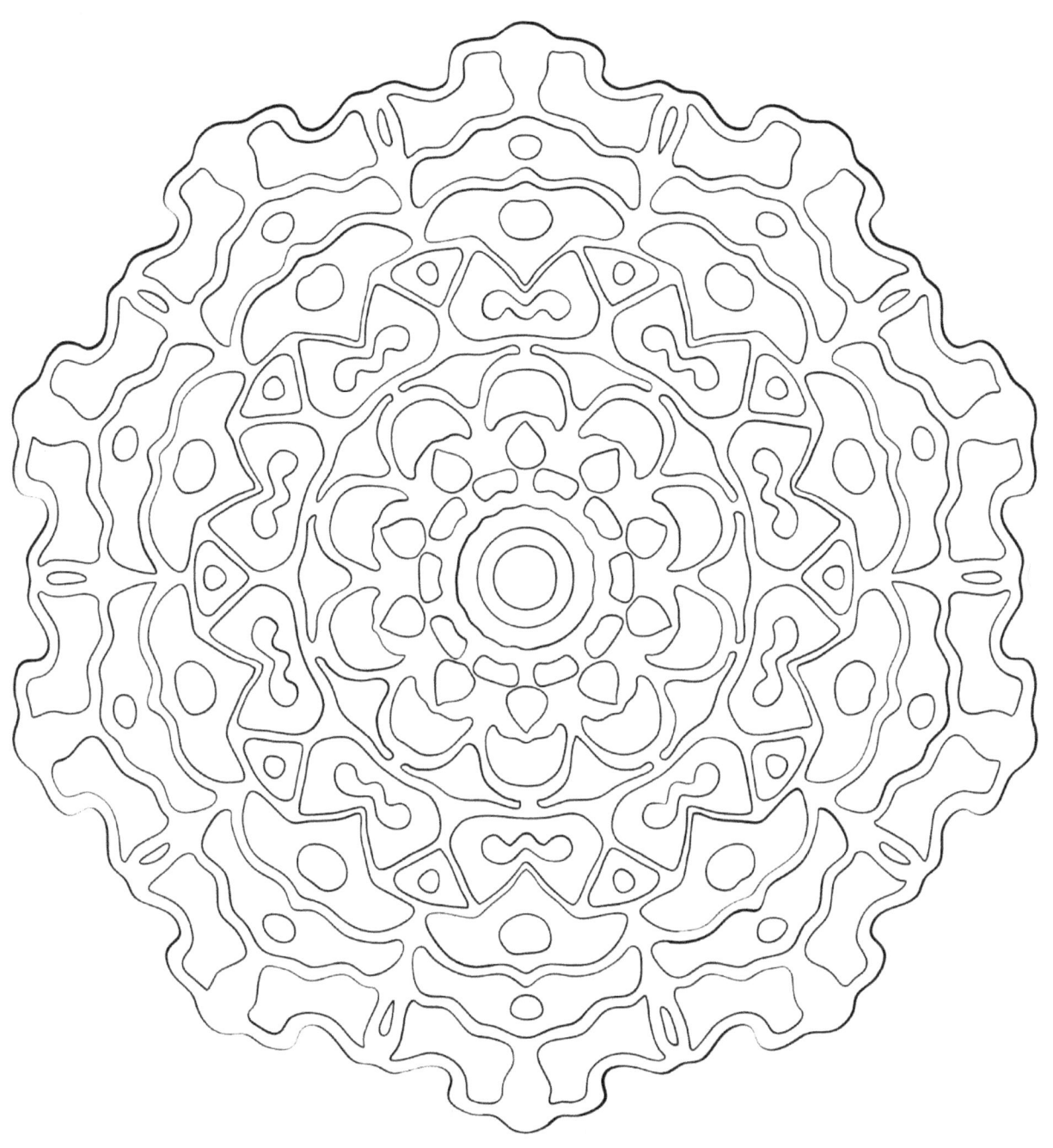

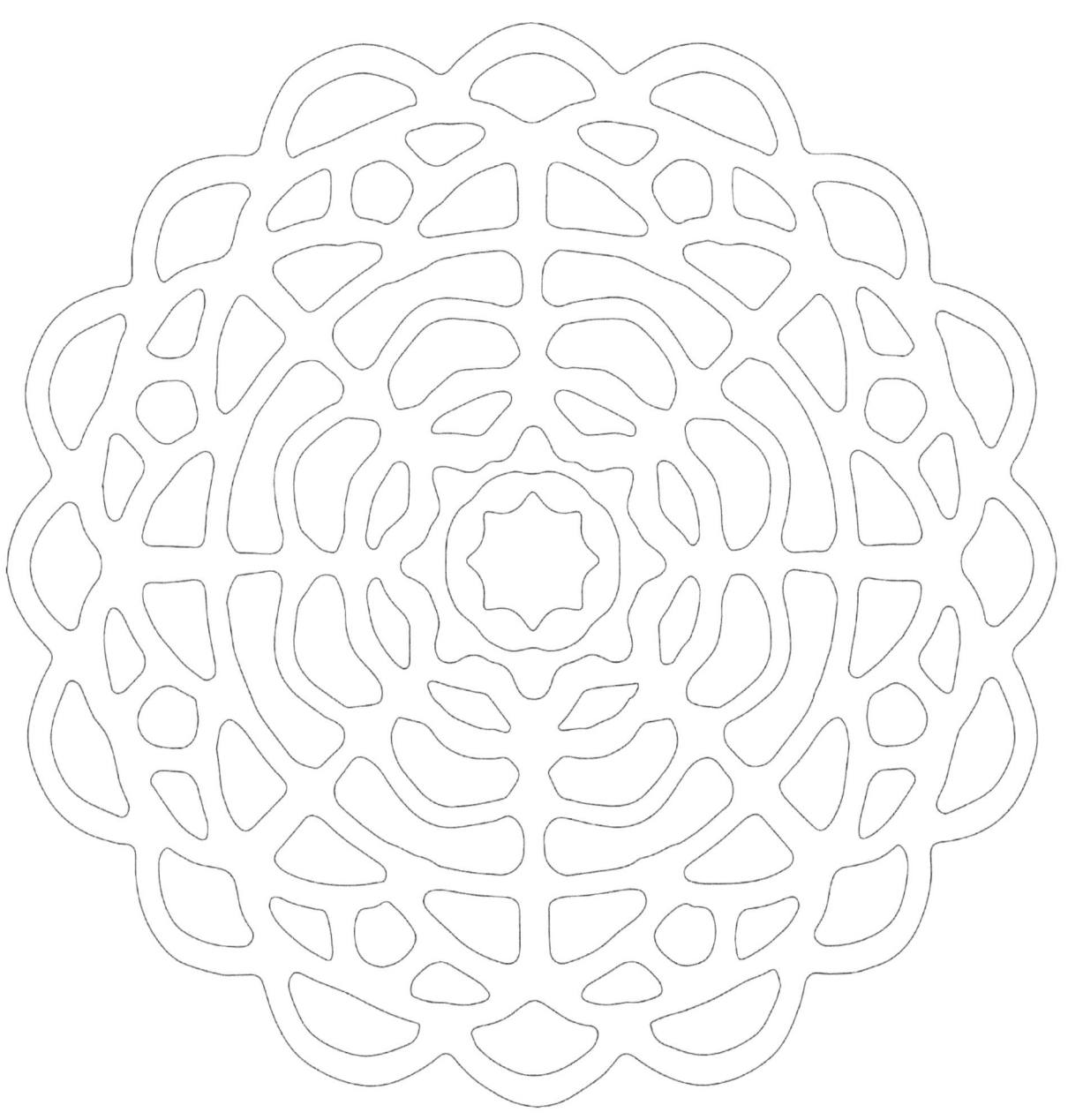

LOUISE ATHERTON

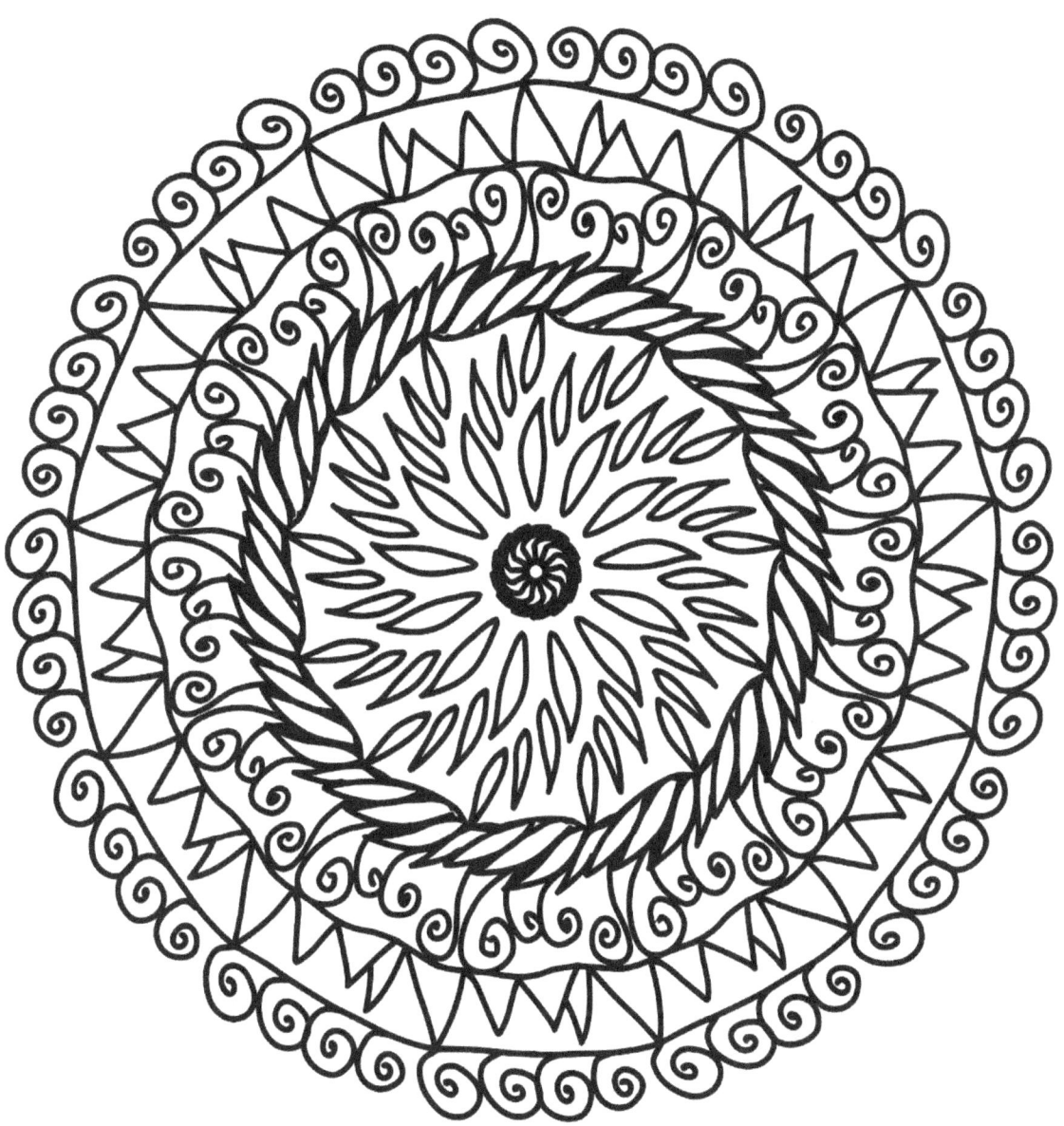

LOUISE ATHERTON

Softness

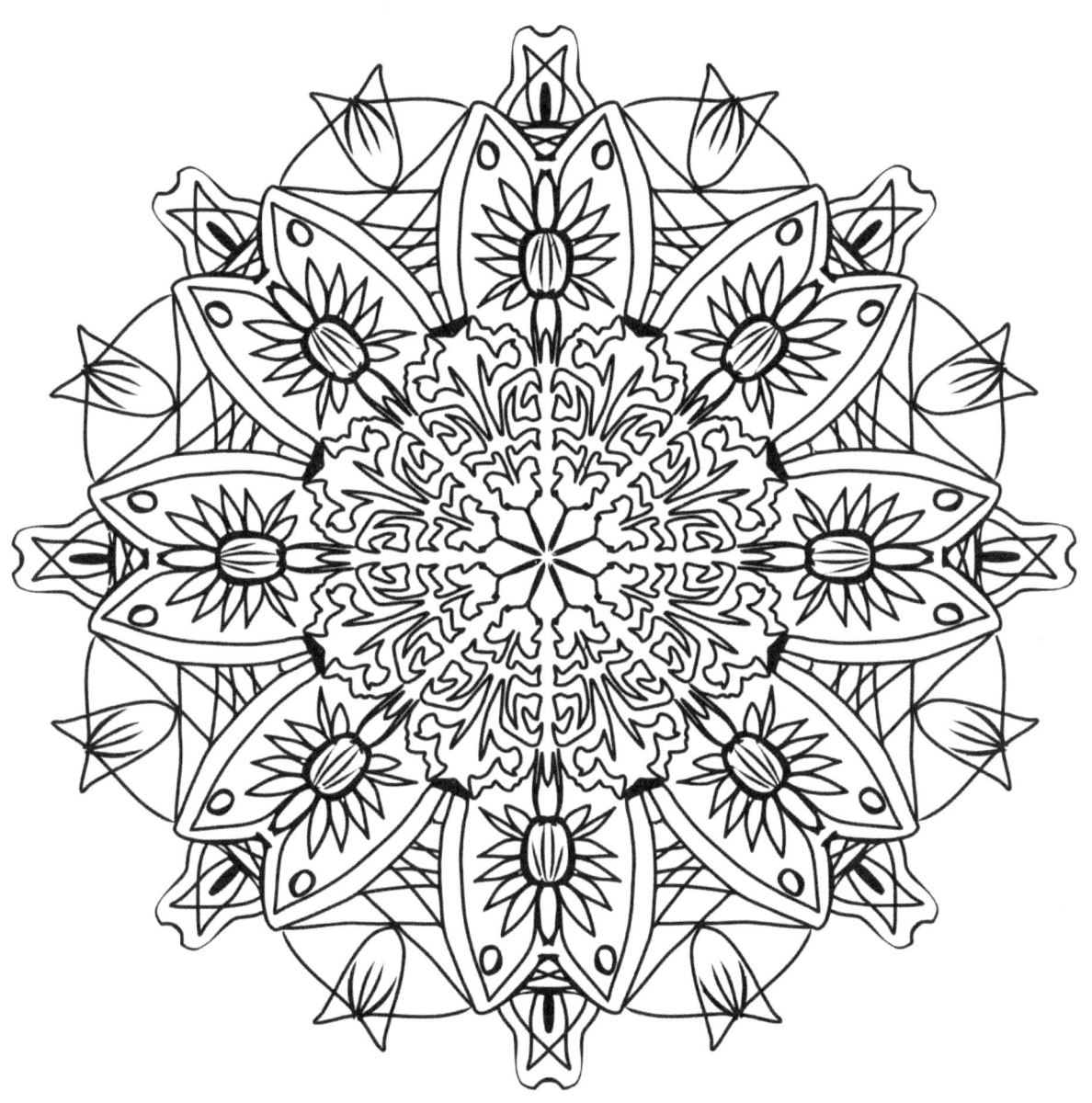

Dance

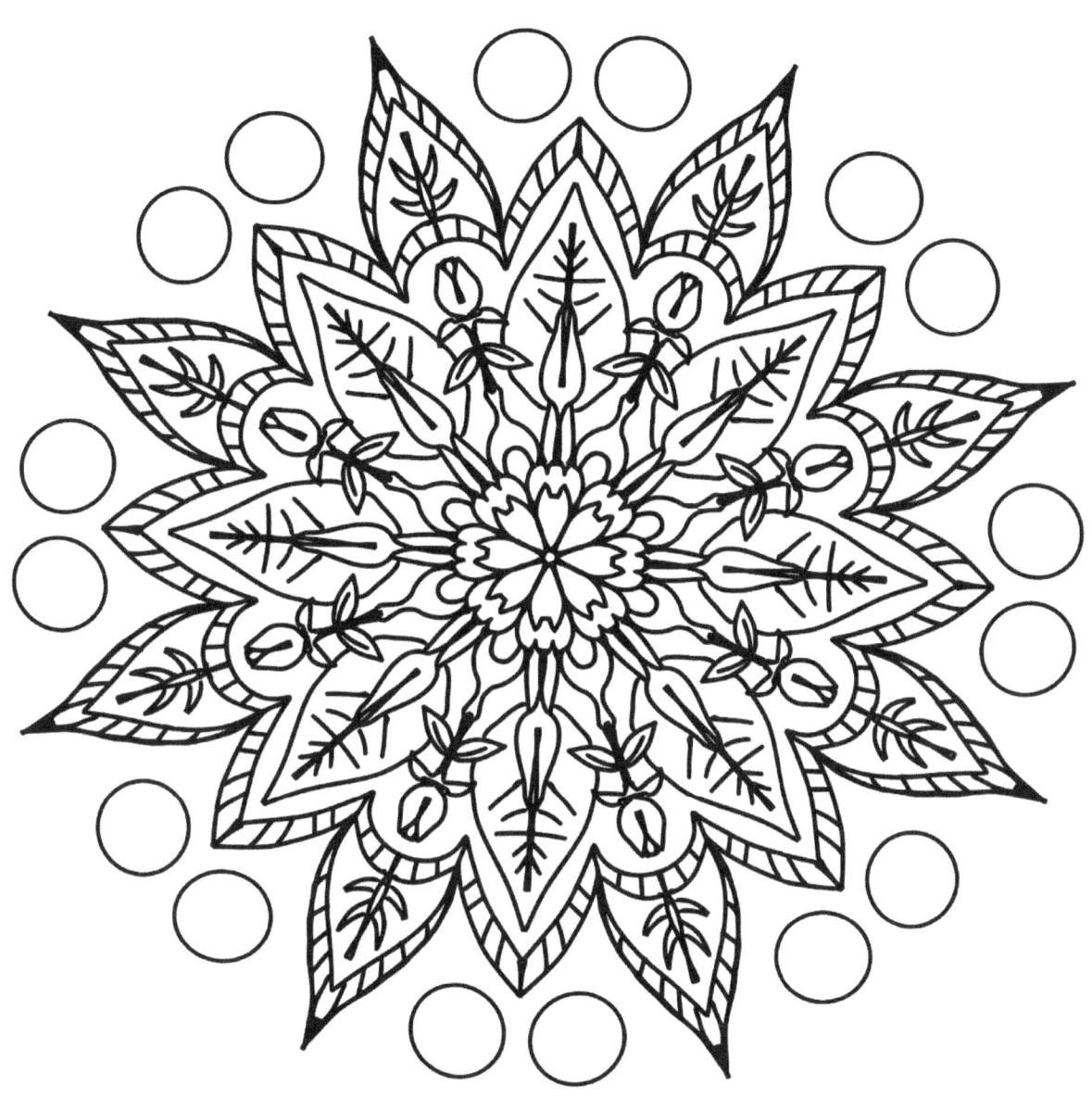

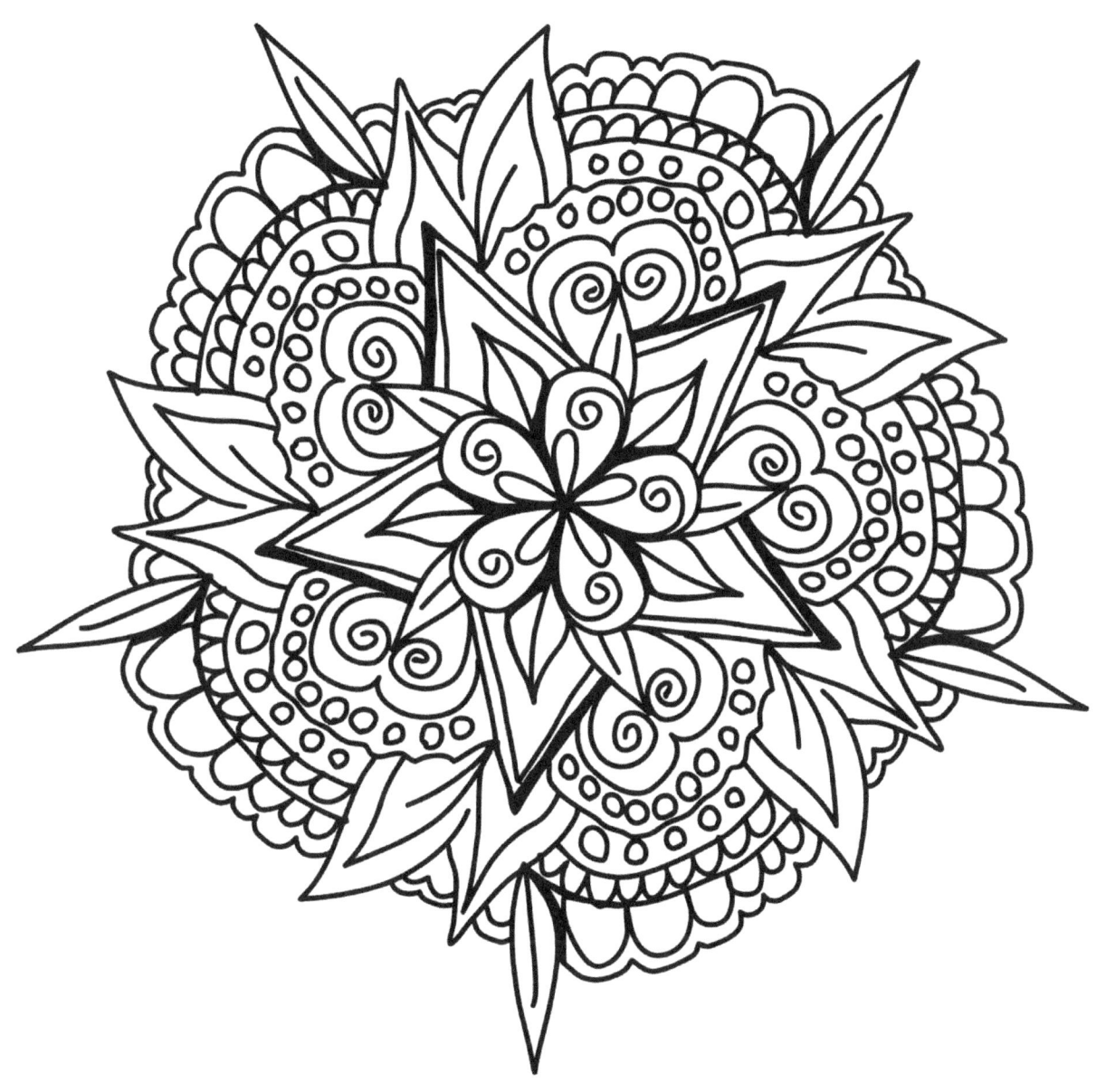

LOUISE ATHERTON

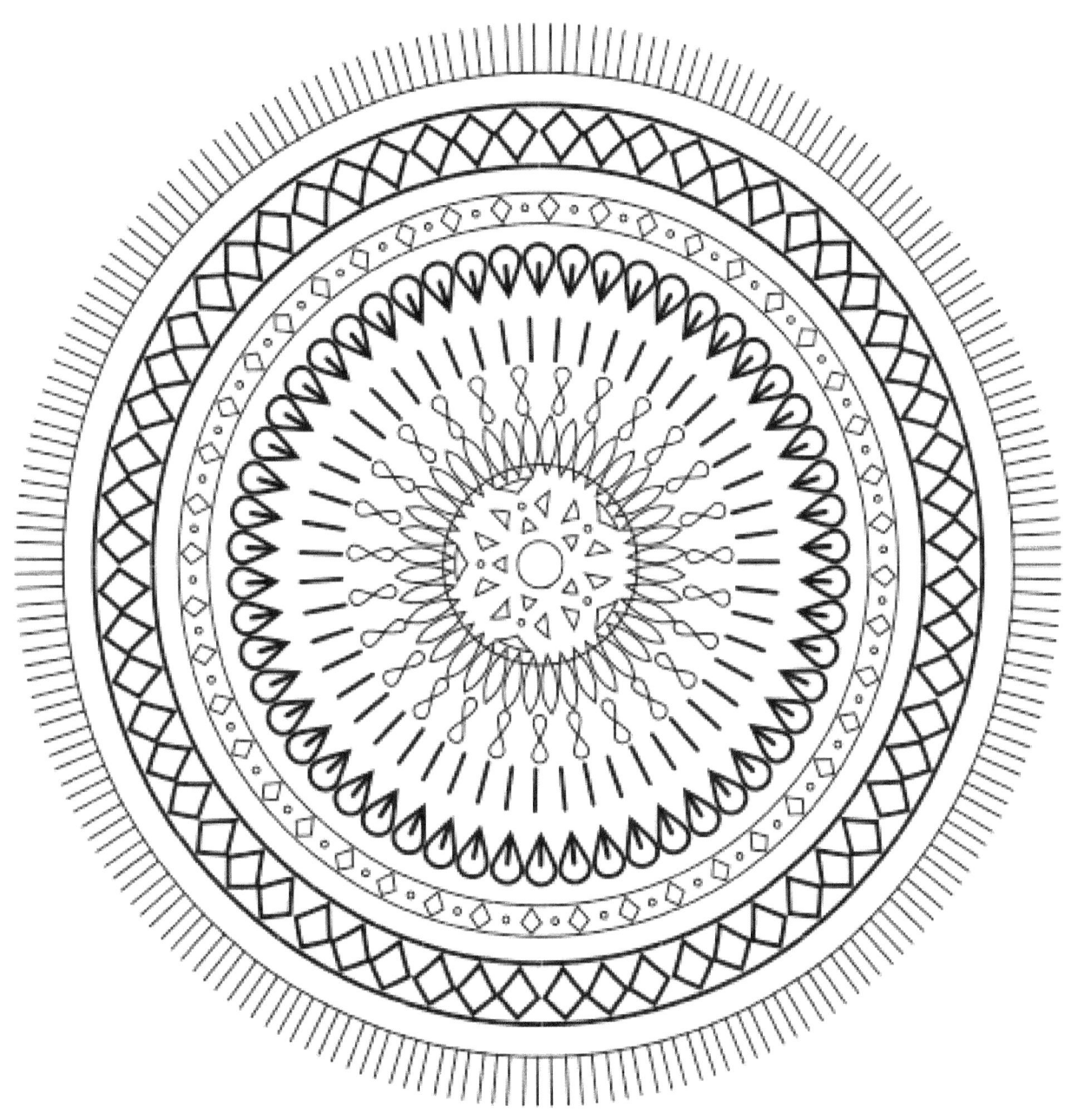

LOUISE ATHERTON

comfort

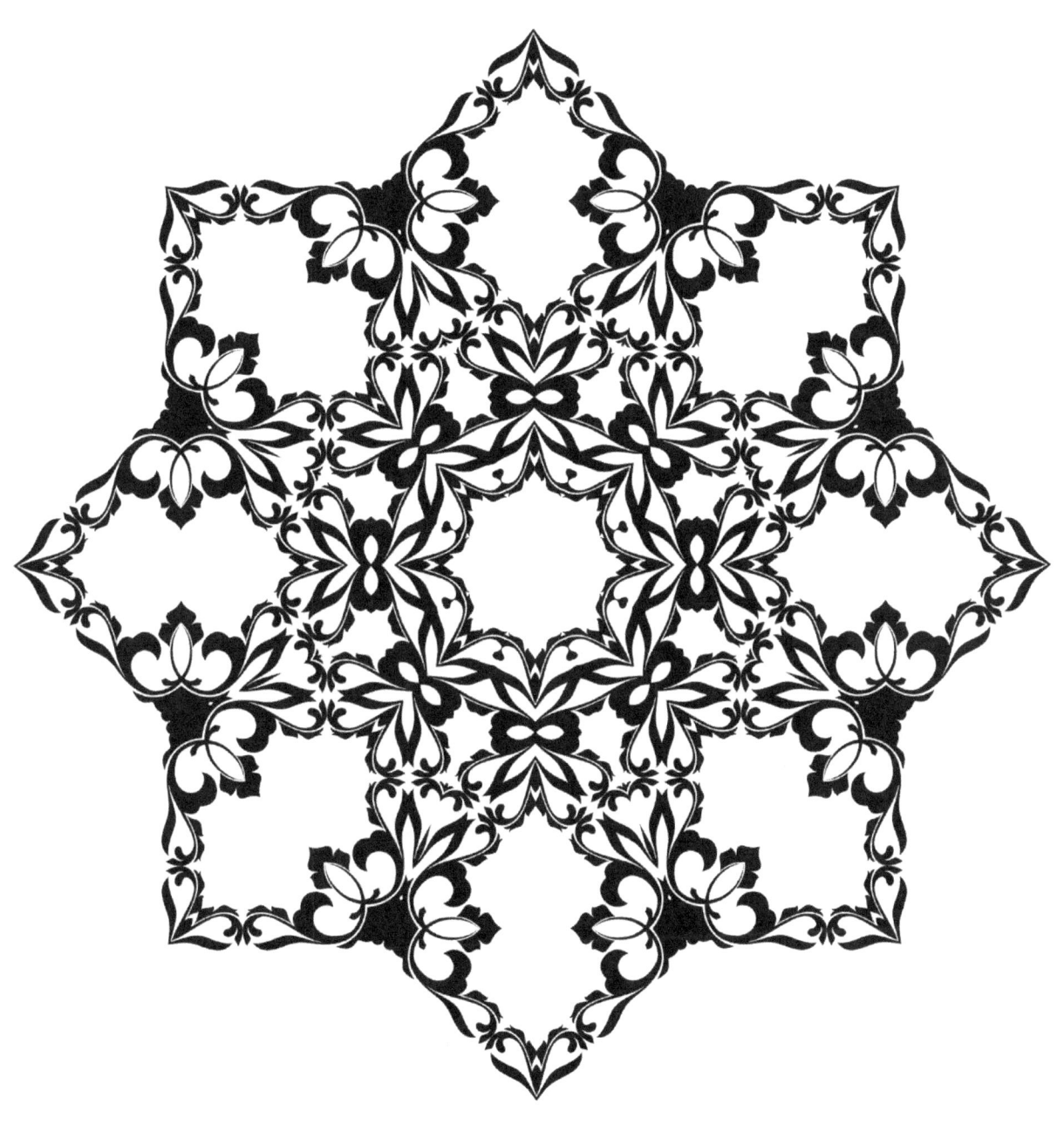

LOUISE ATHERTON

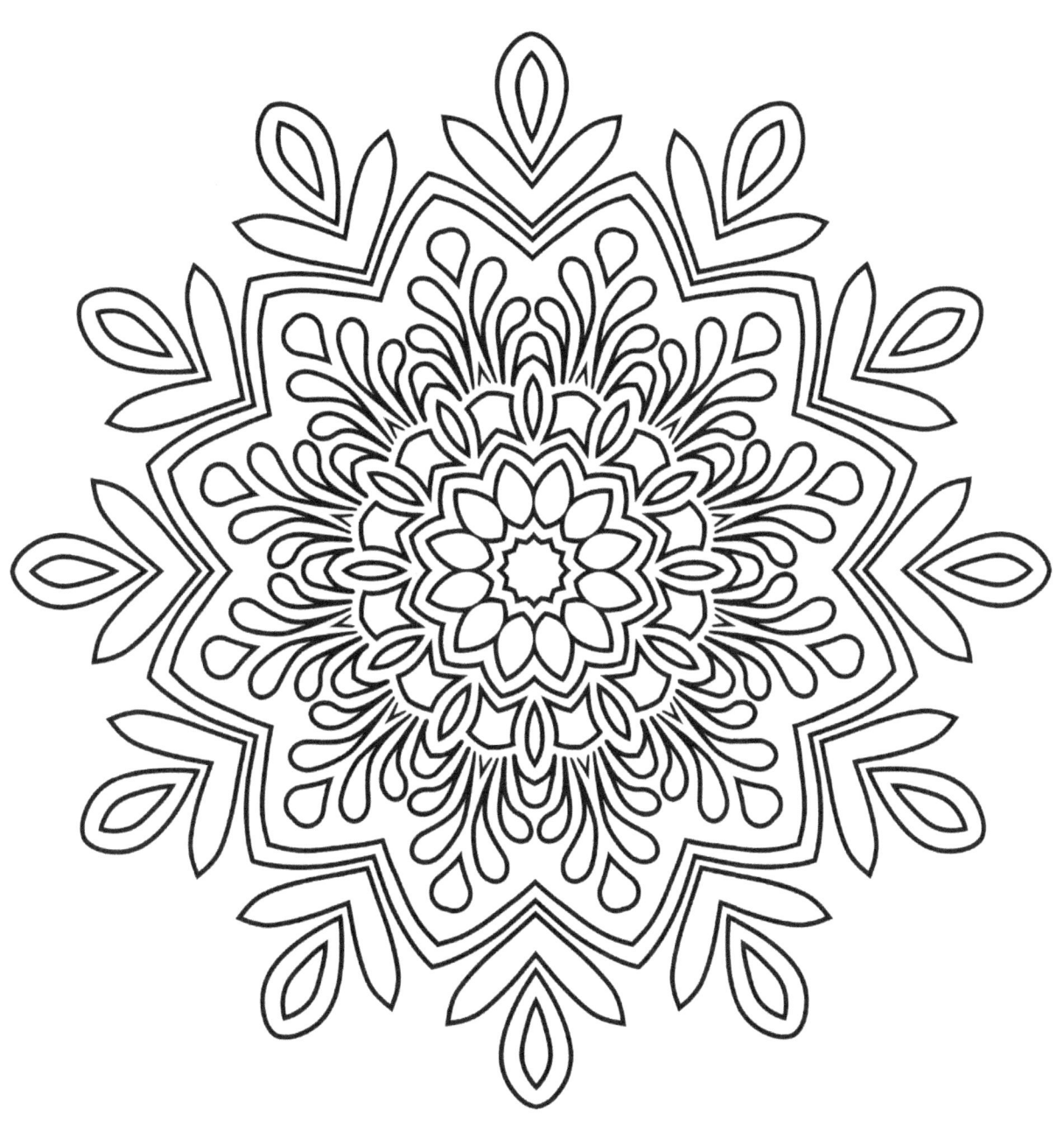

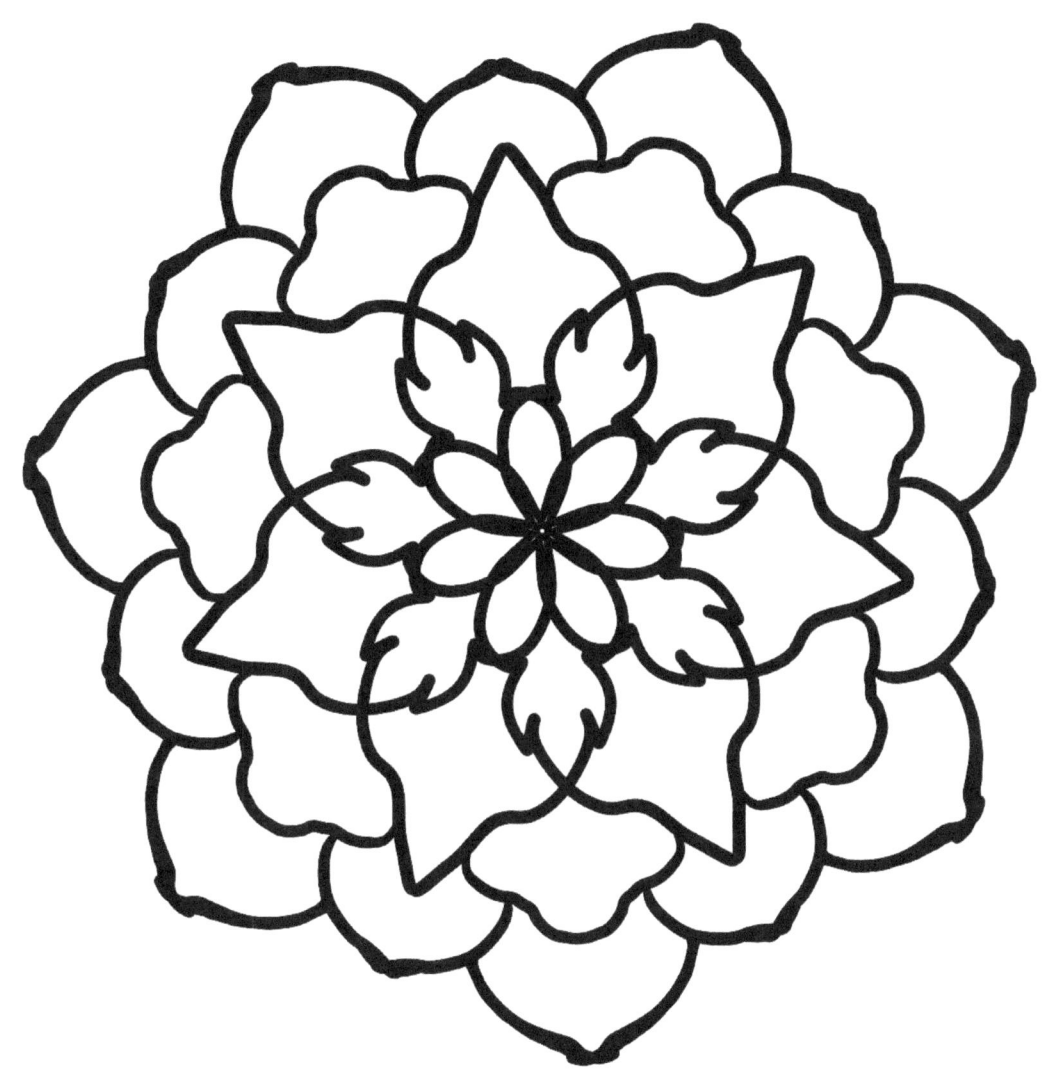

LOUISE ATHERTON

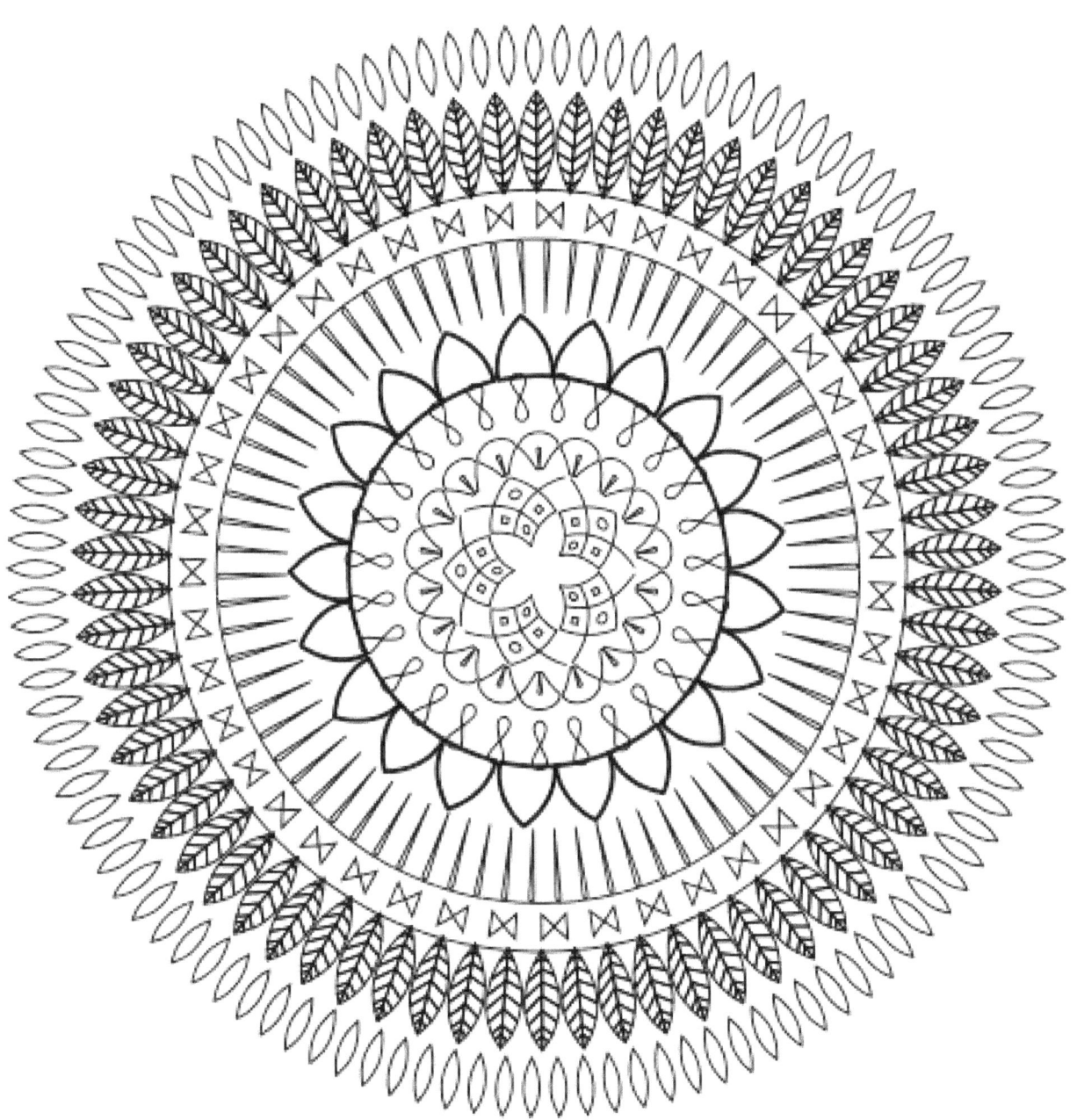

smell

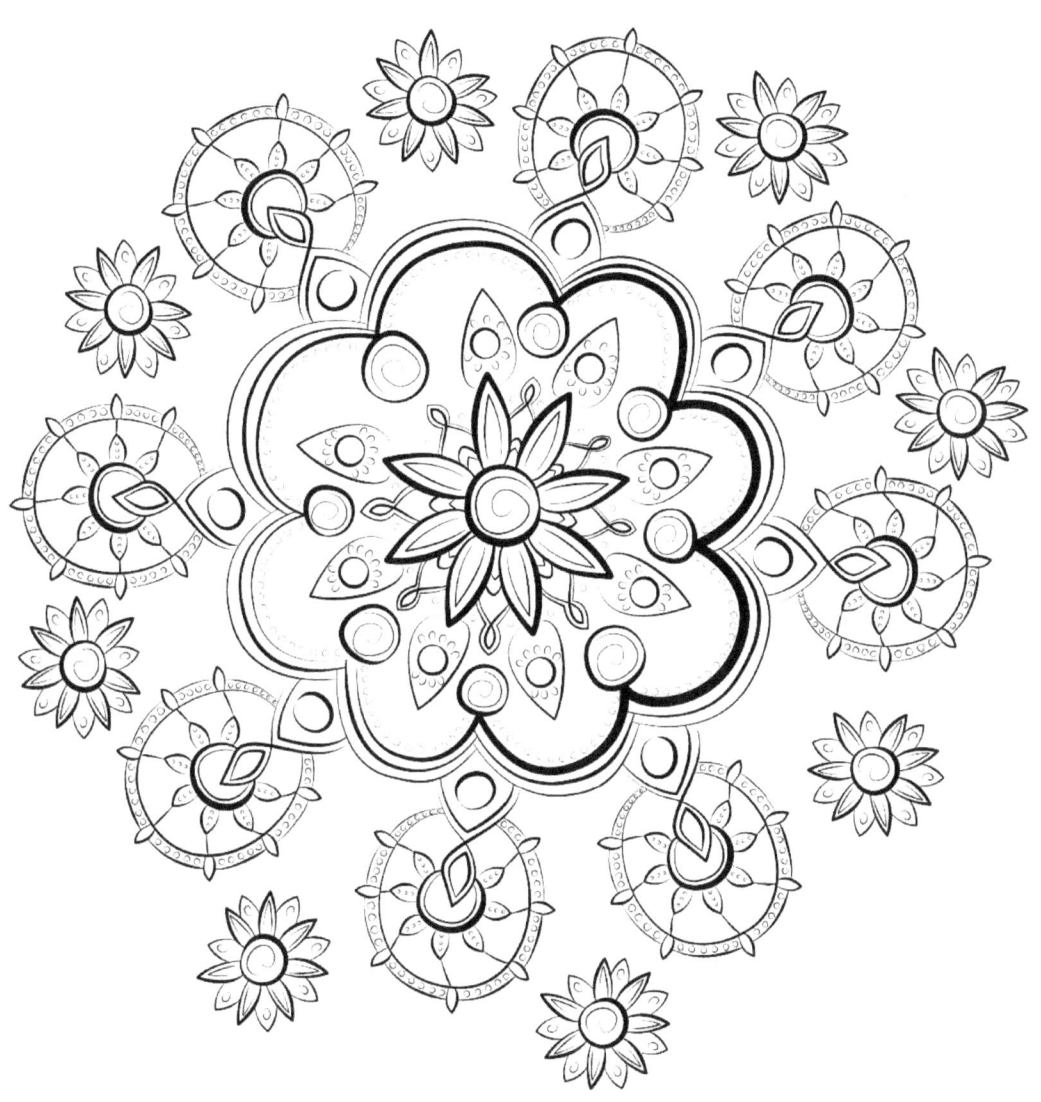

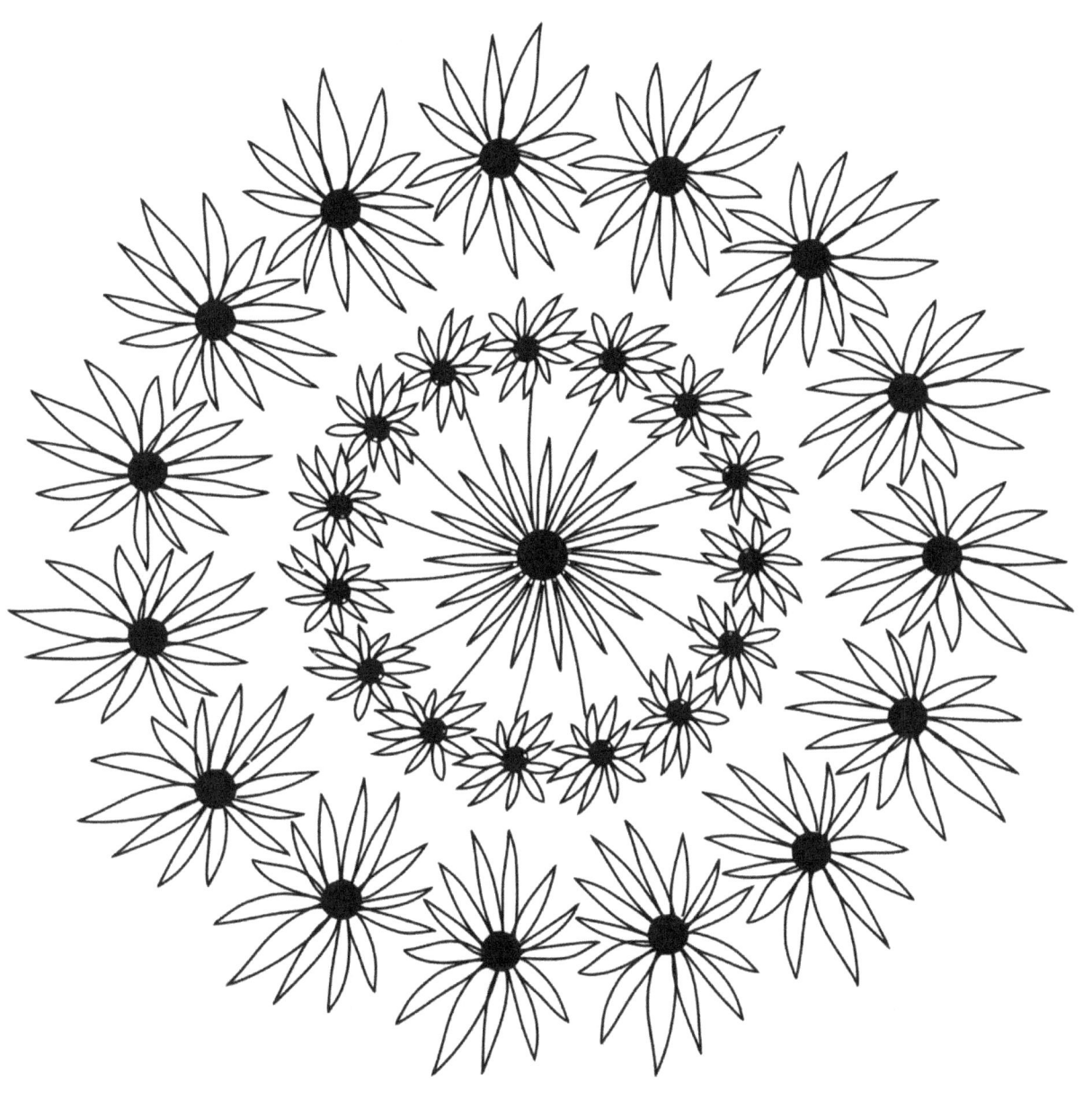

LOUISE ATHERTON

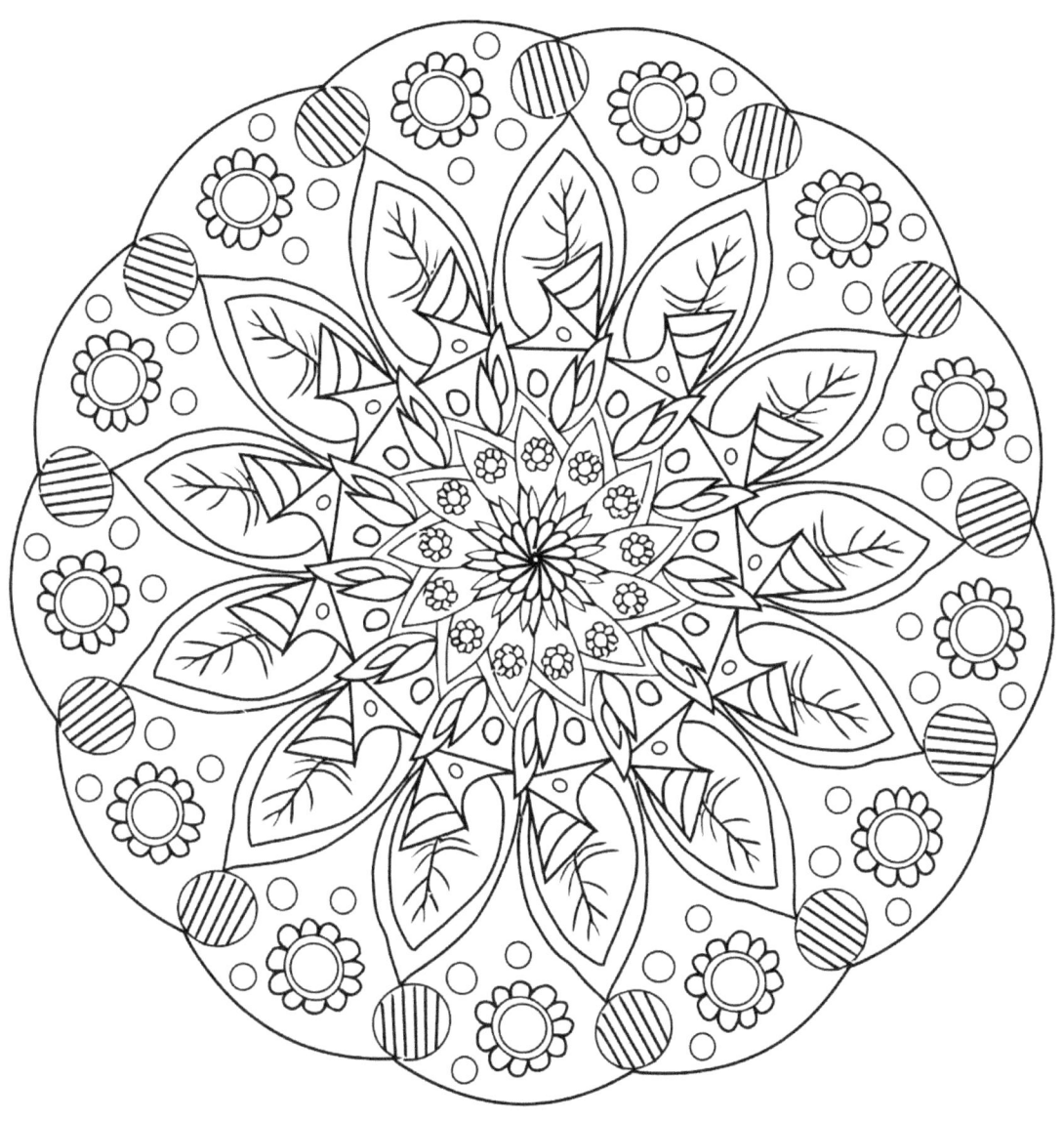

LOUISE ATHERTON

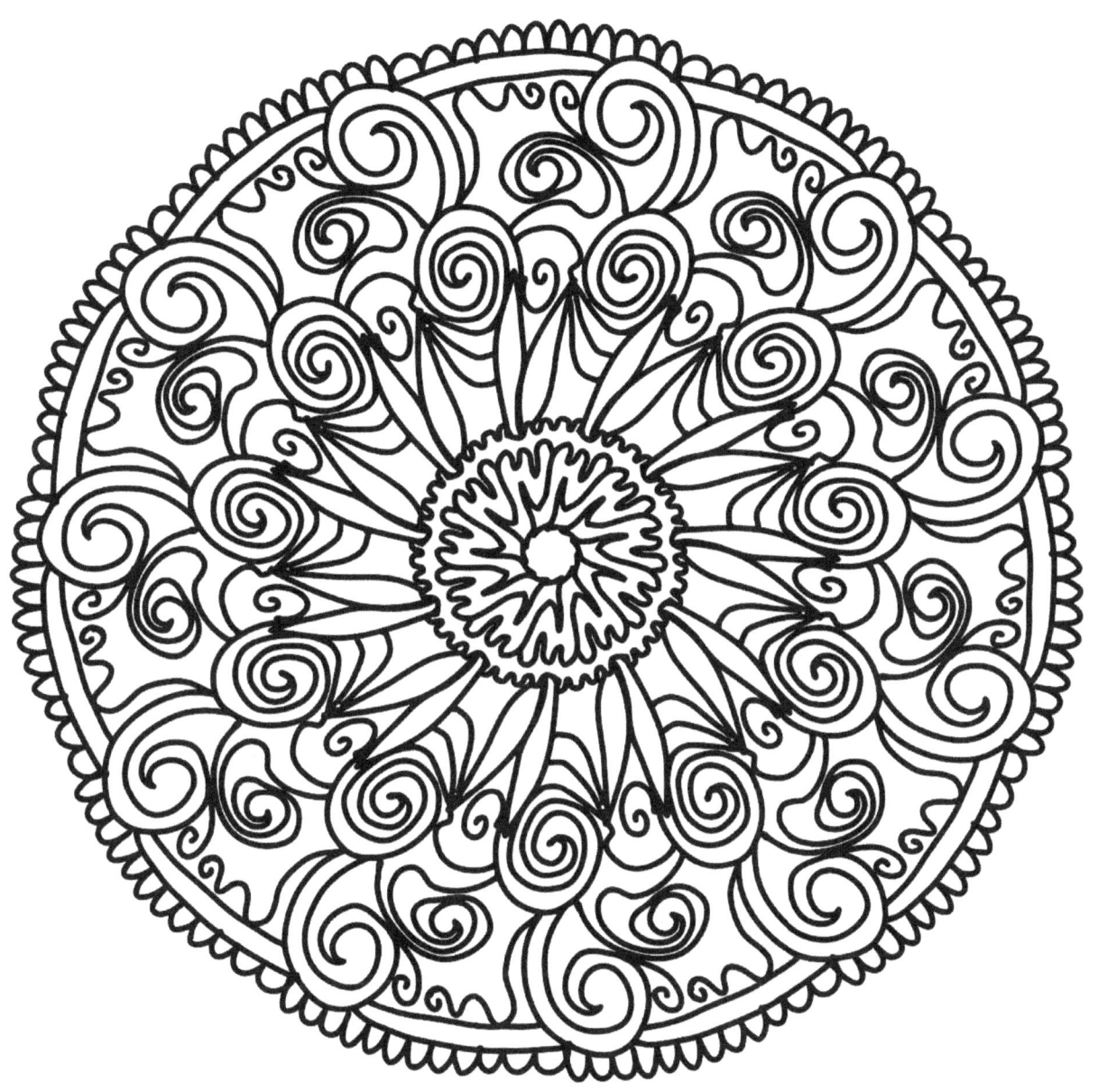

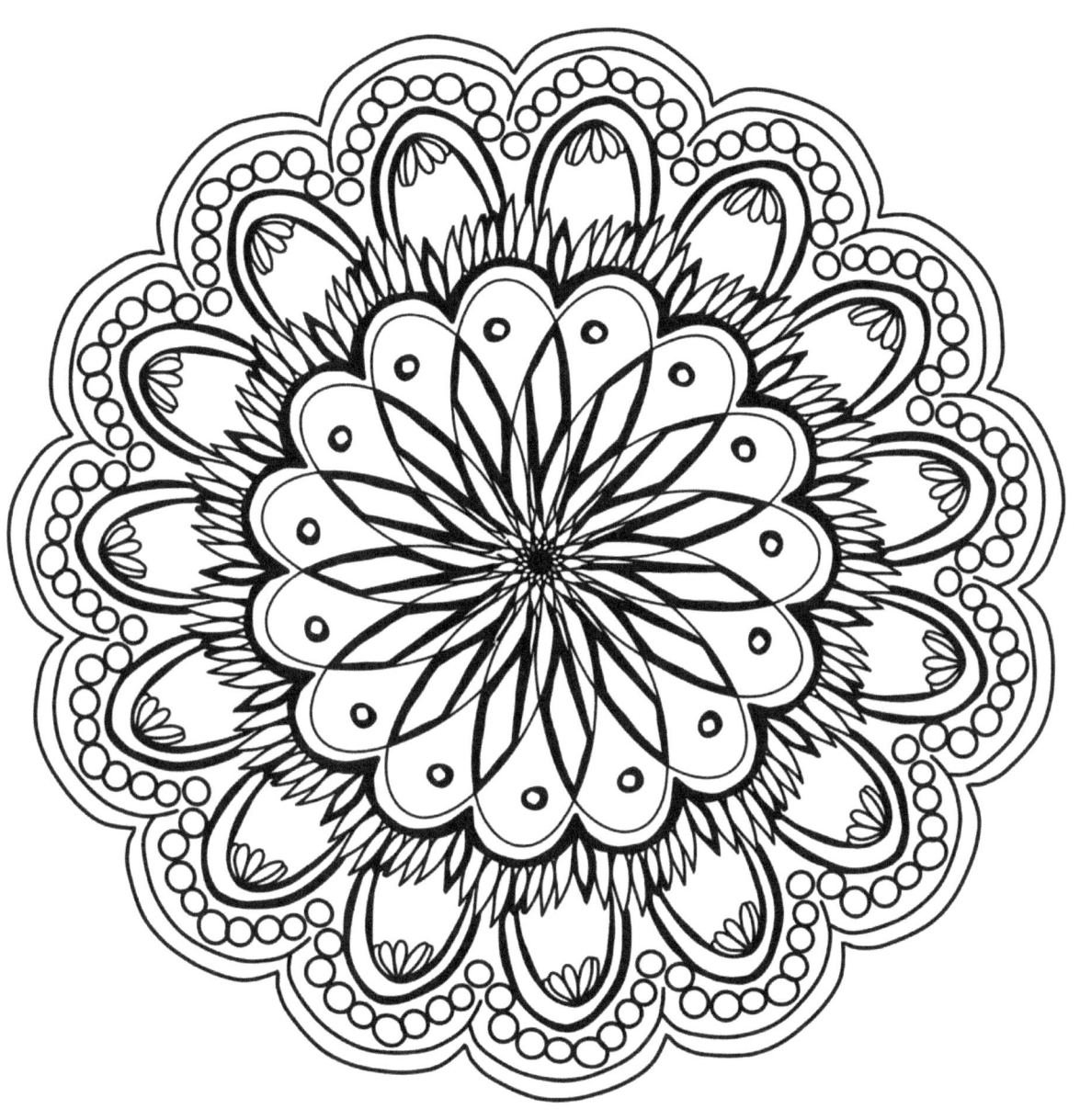

Serene

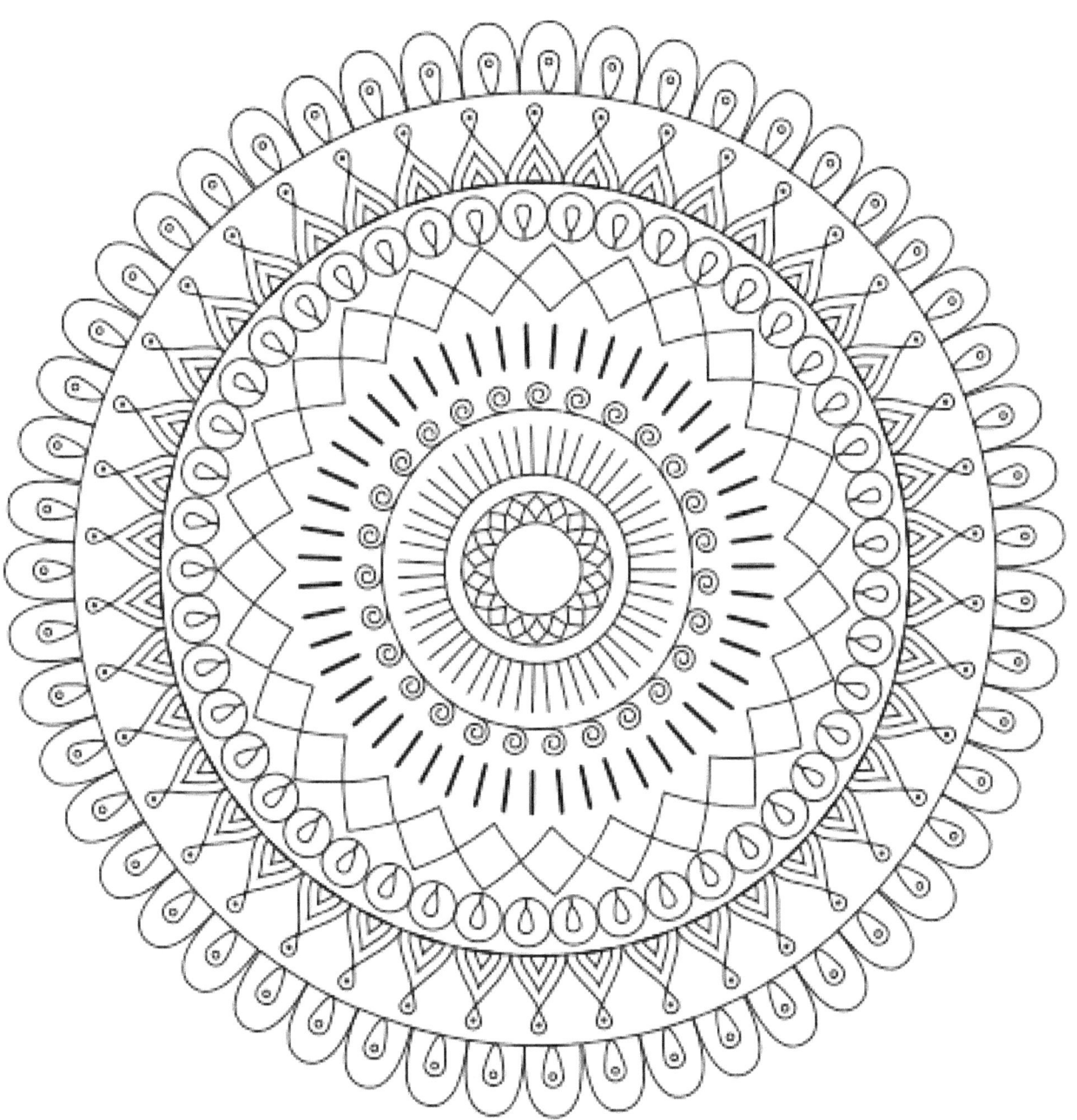

LOUISE ATHERTON

Senses

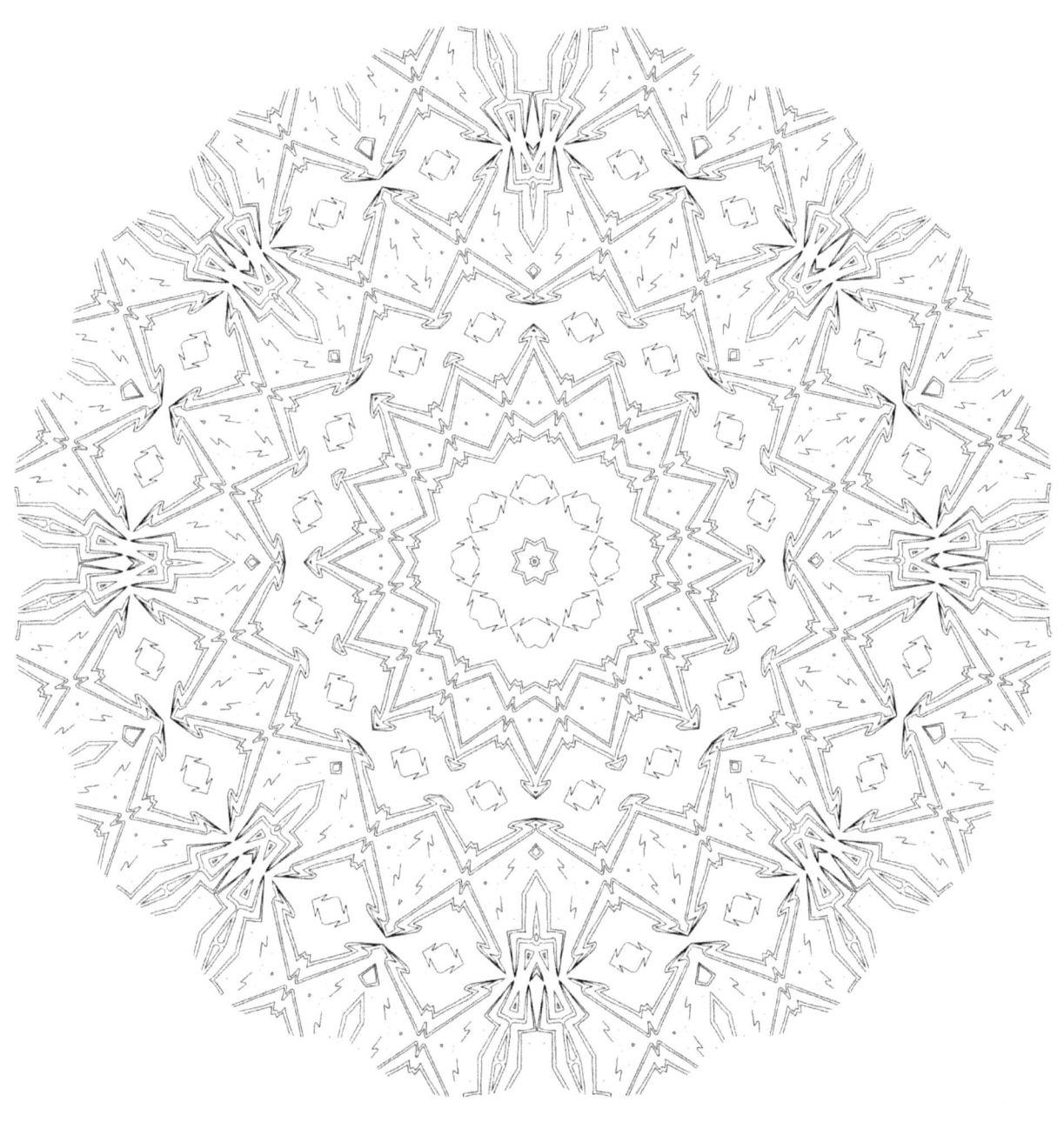

COLOR MY MANDALAS

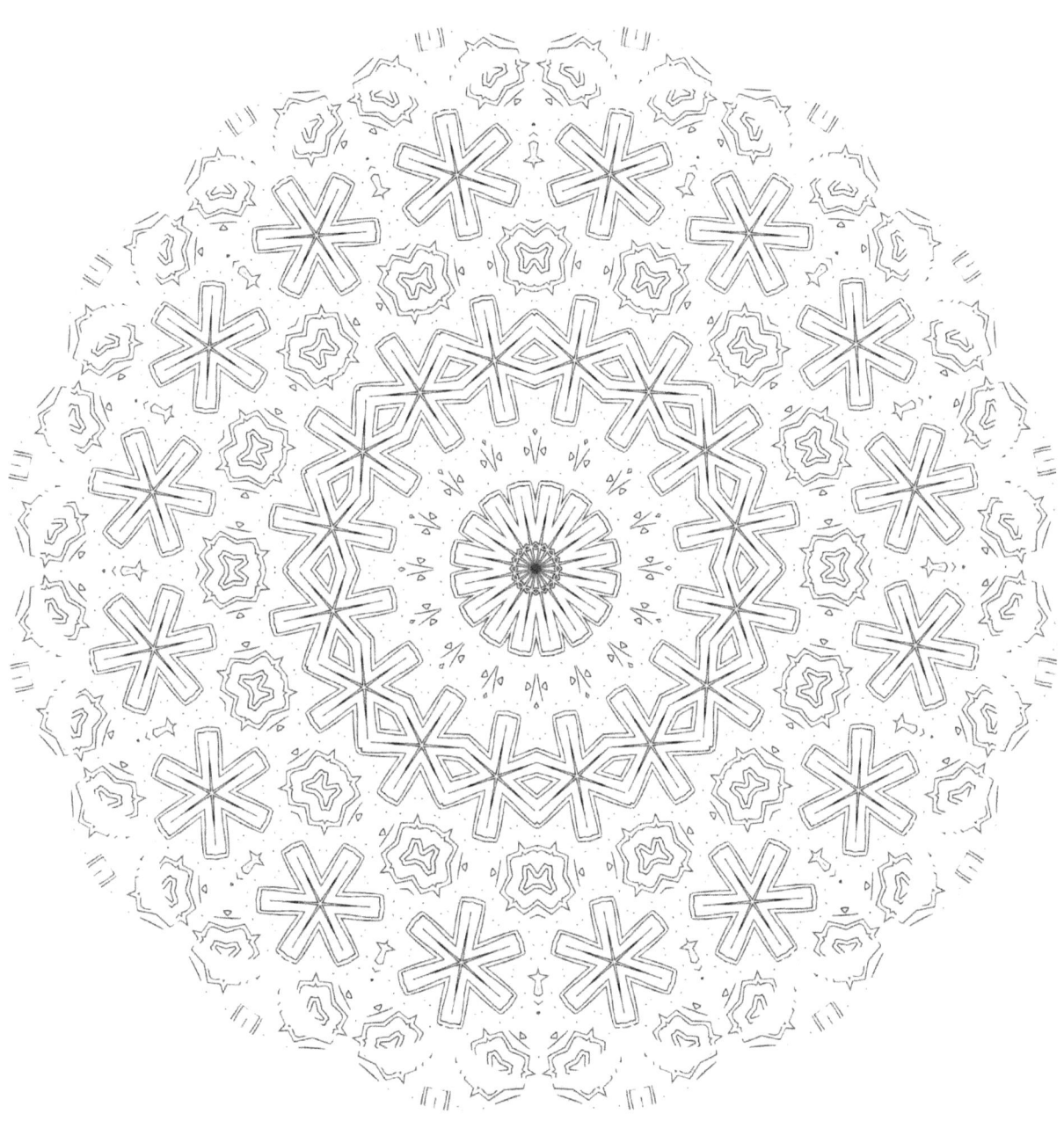

LOUISE ATHERTON

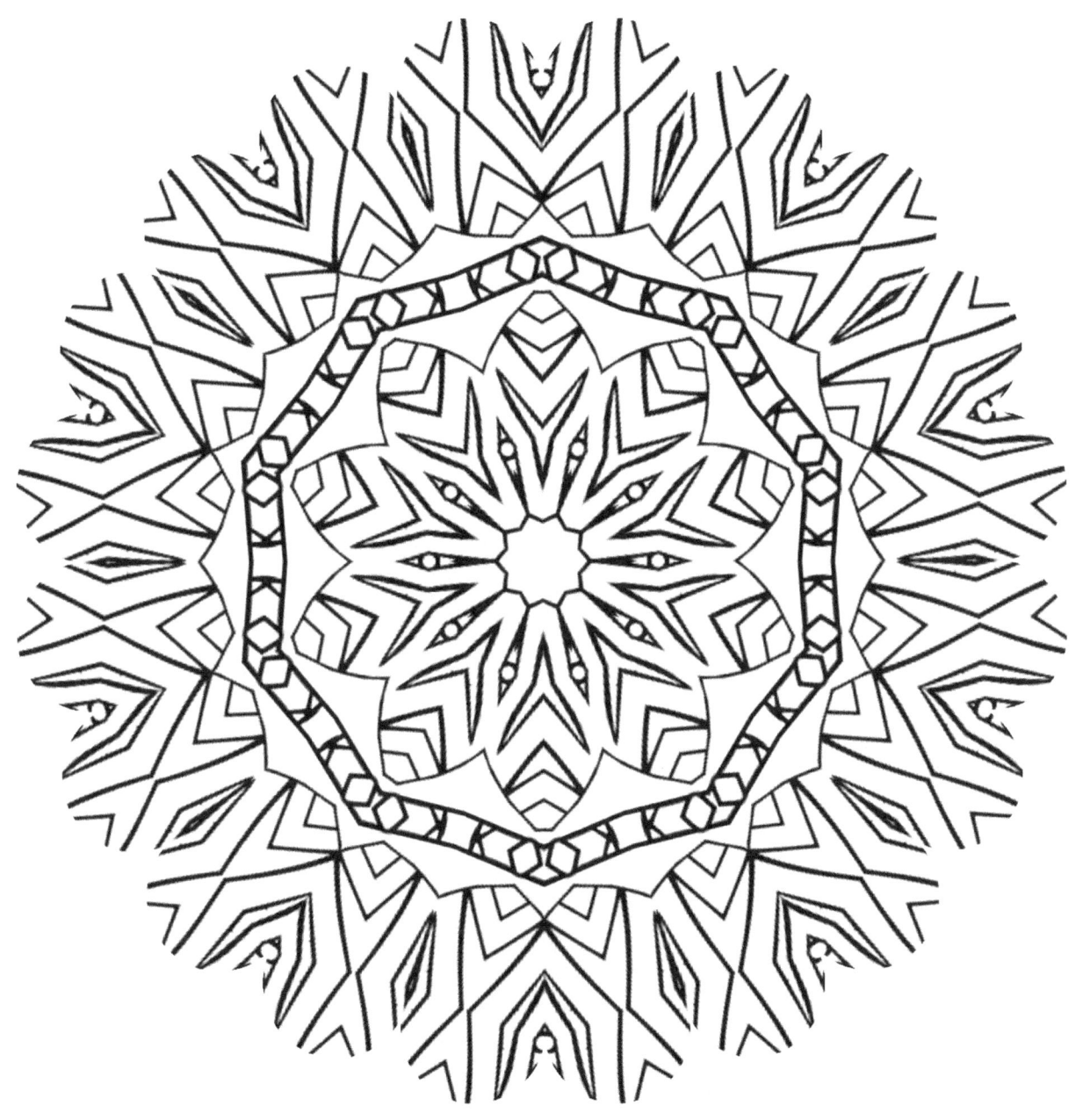

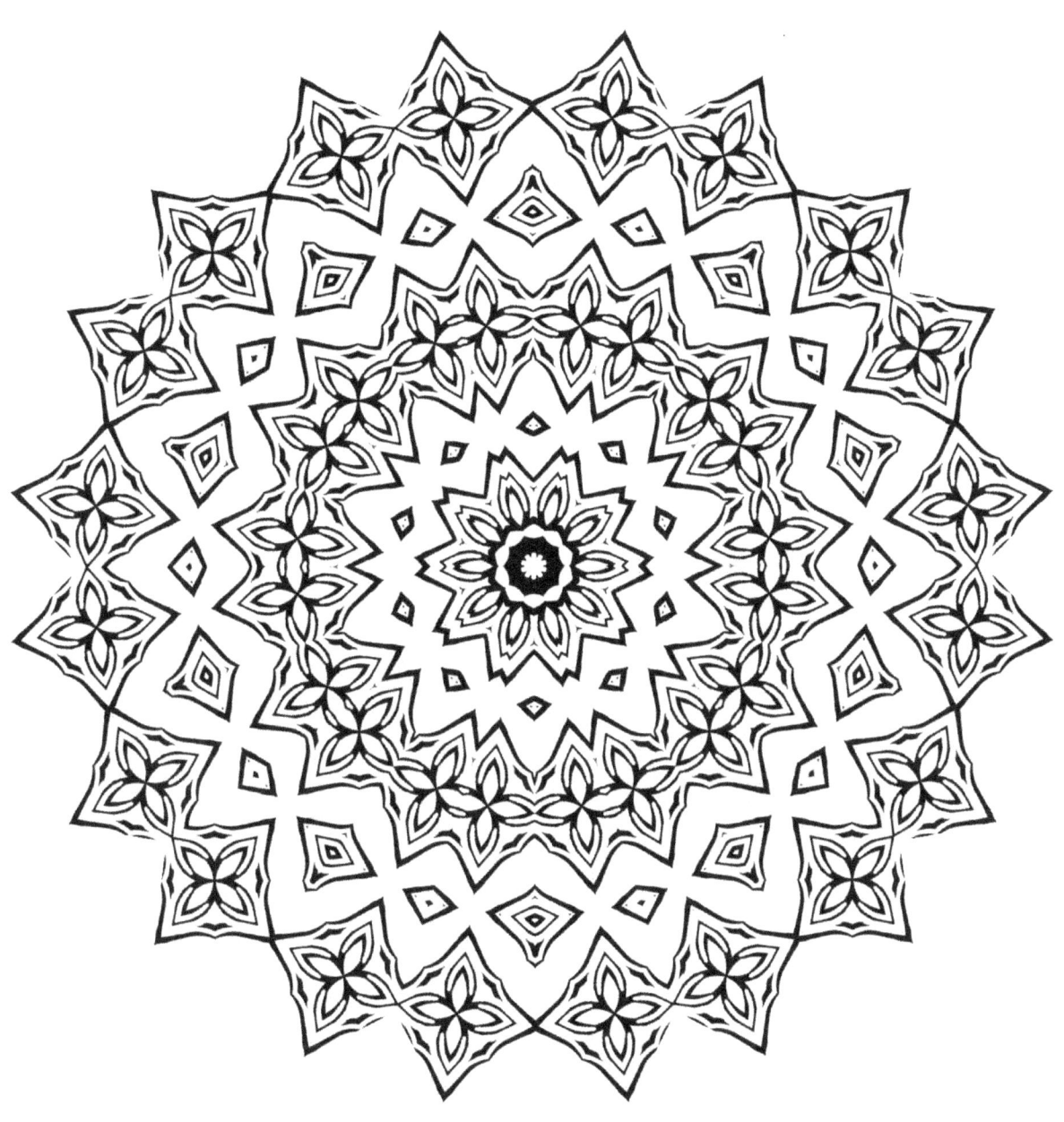

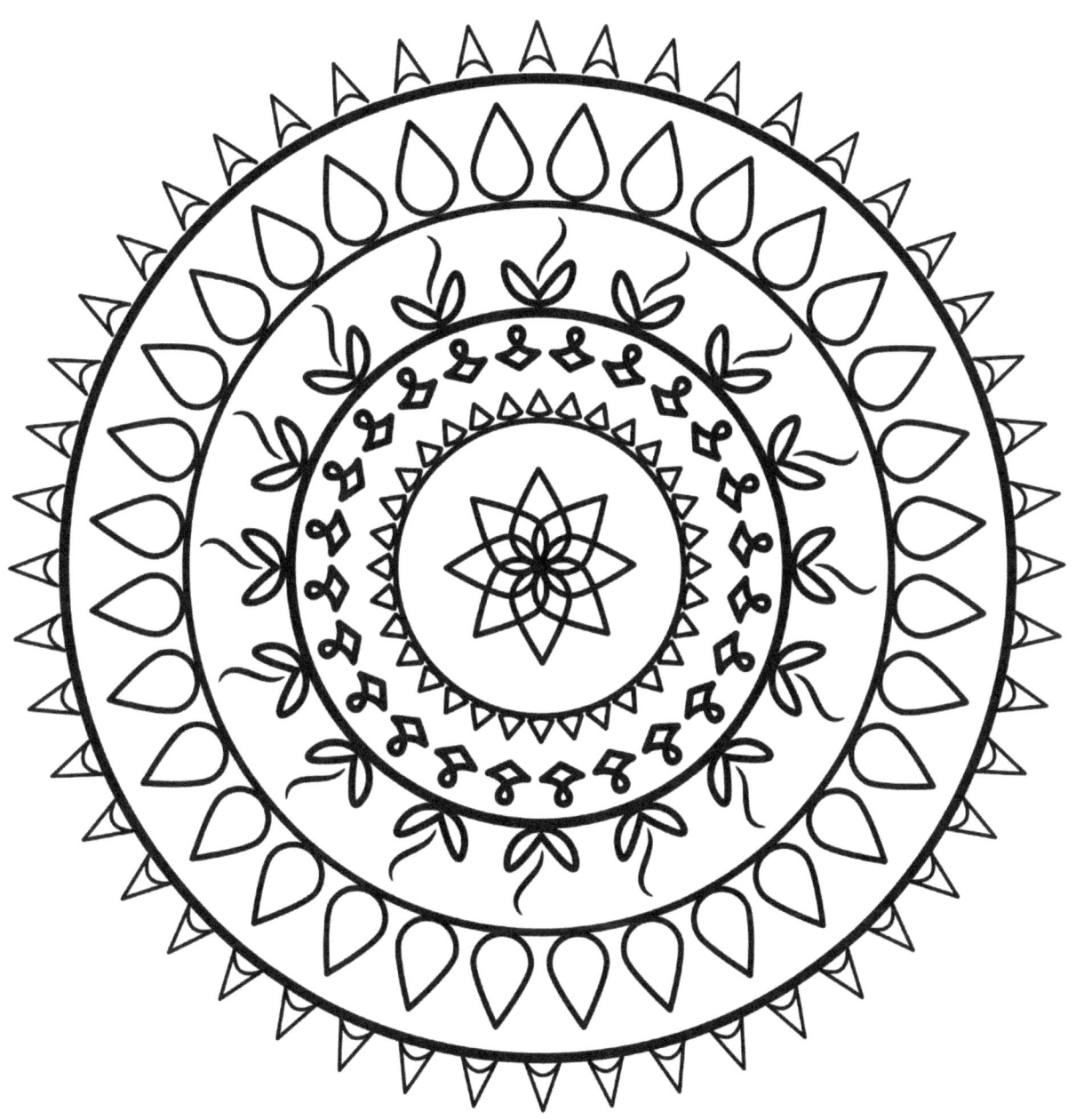

Joyous

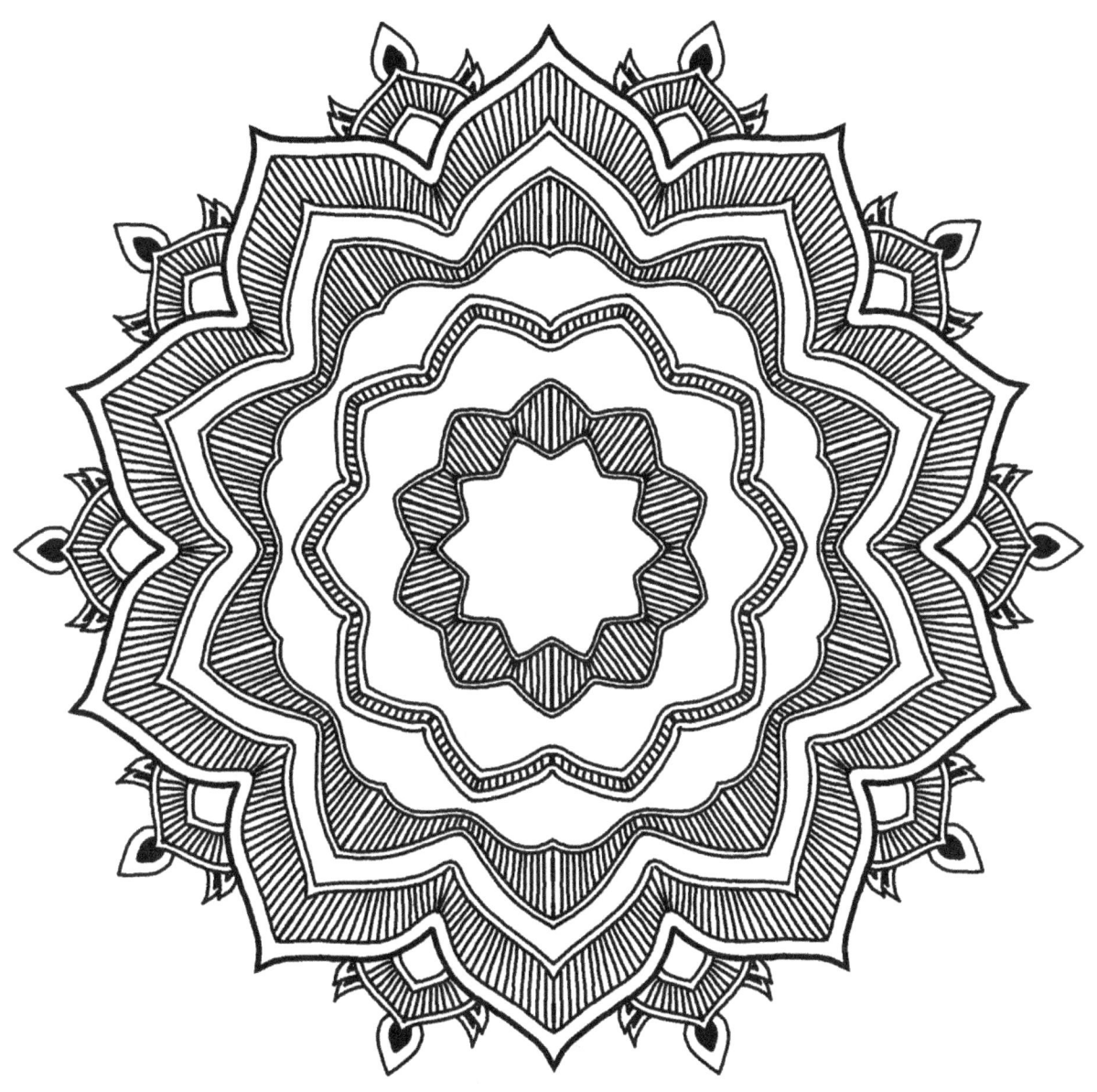

LOUISE ATHERTON

Harmony

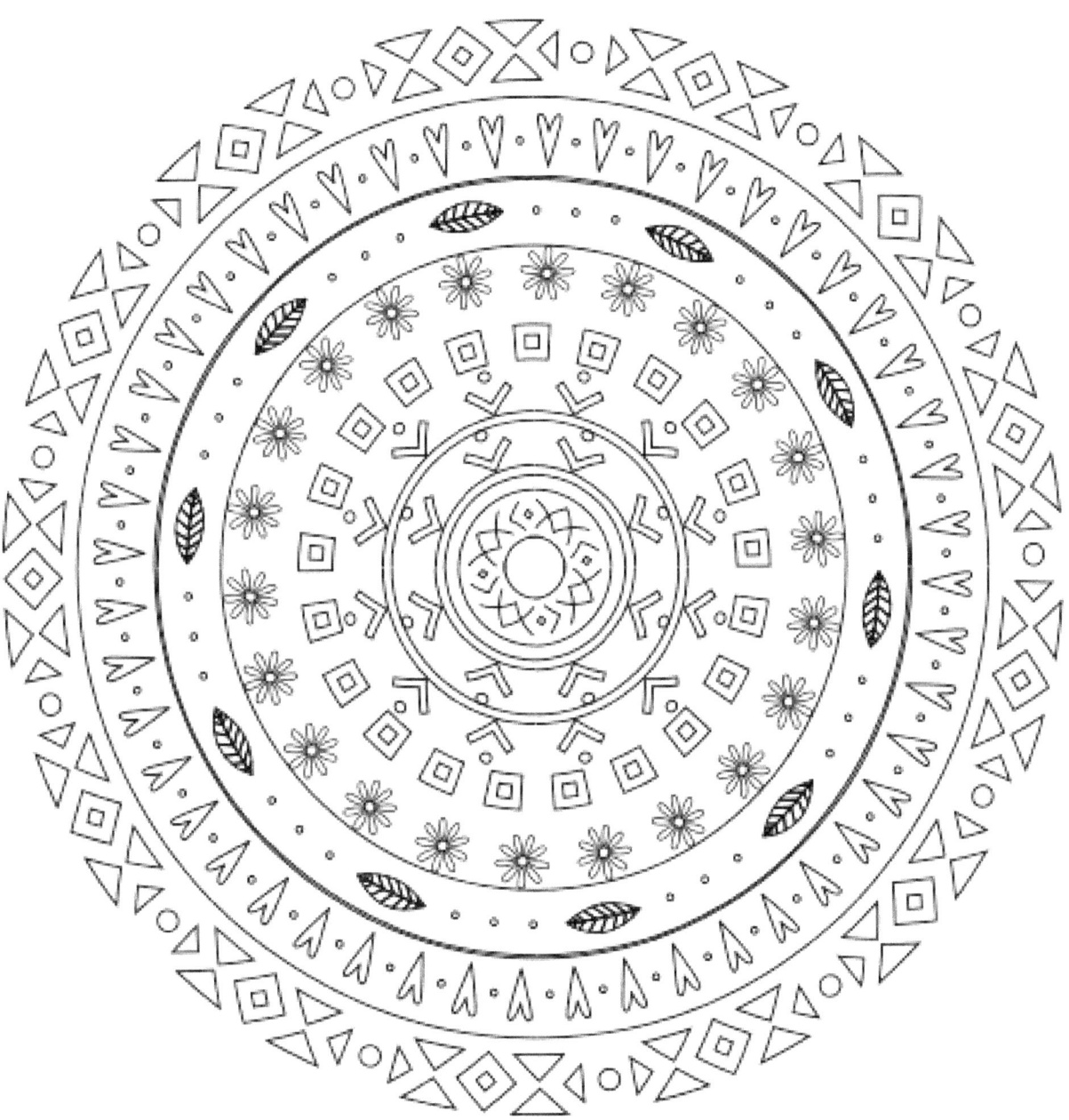

LOUISE ATHERTON

Belonging

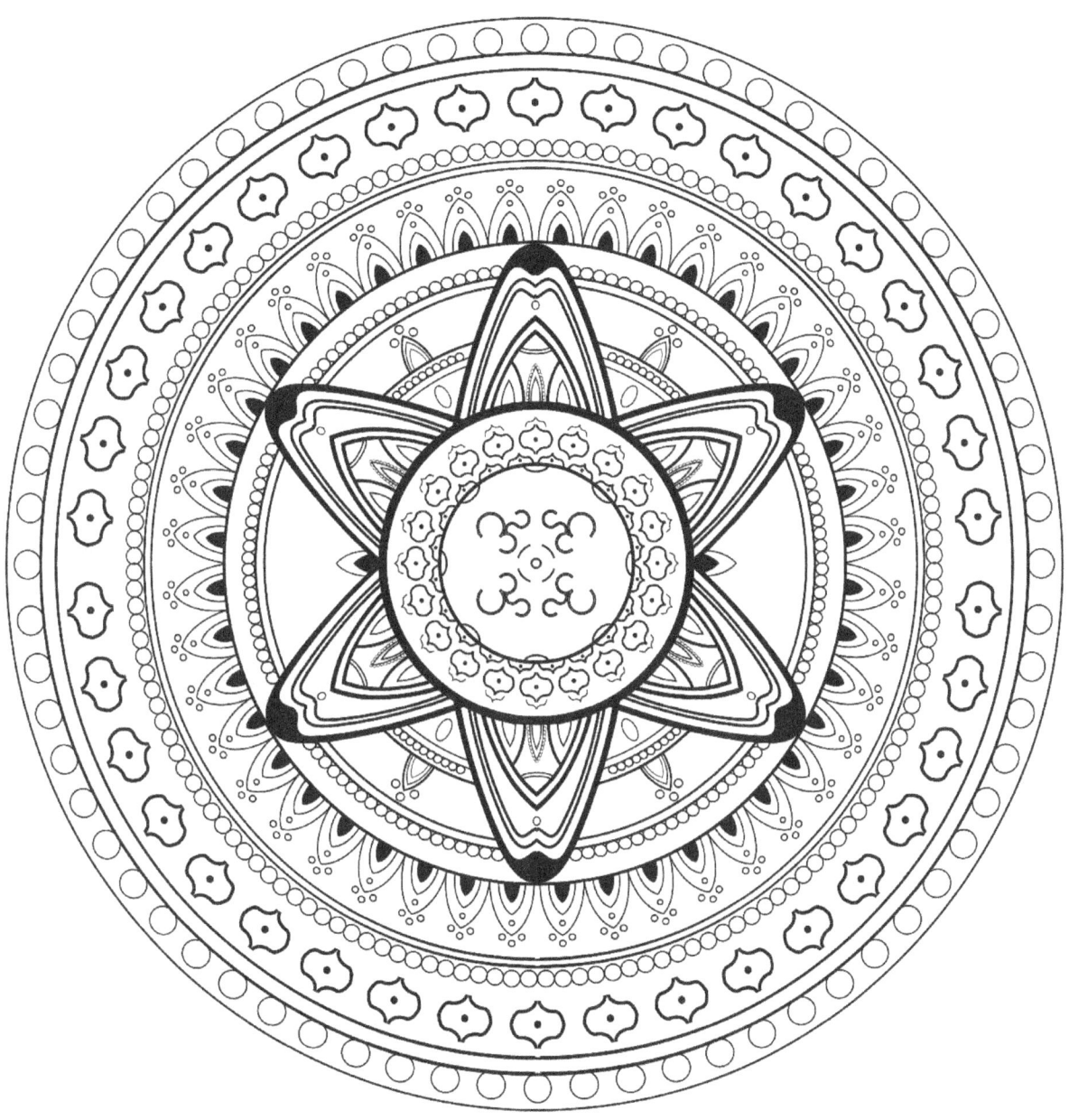

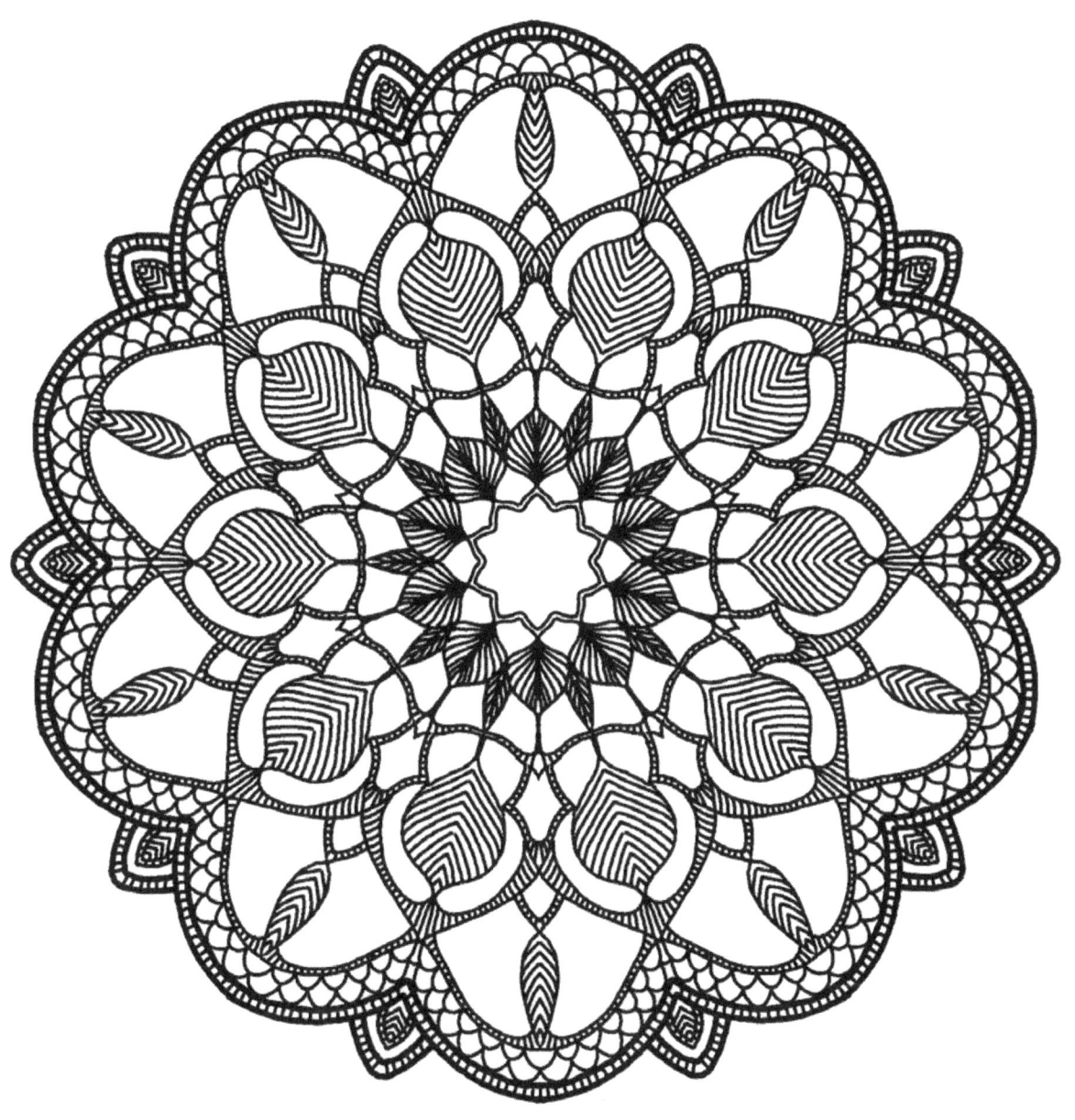

Together

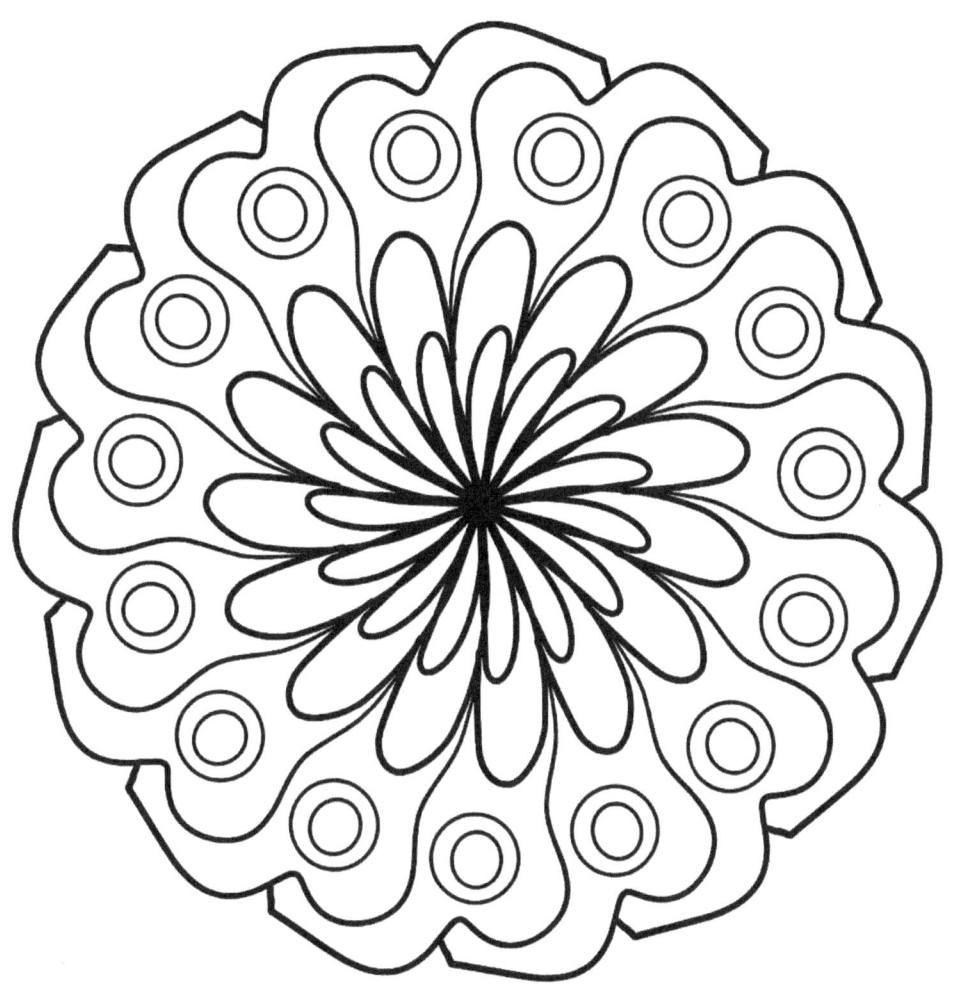

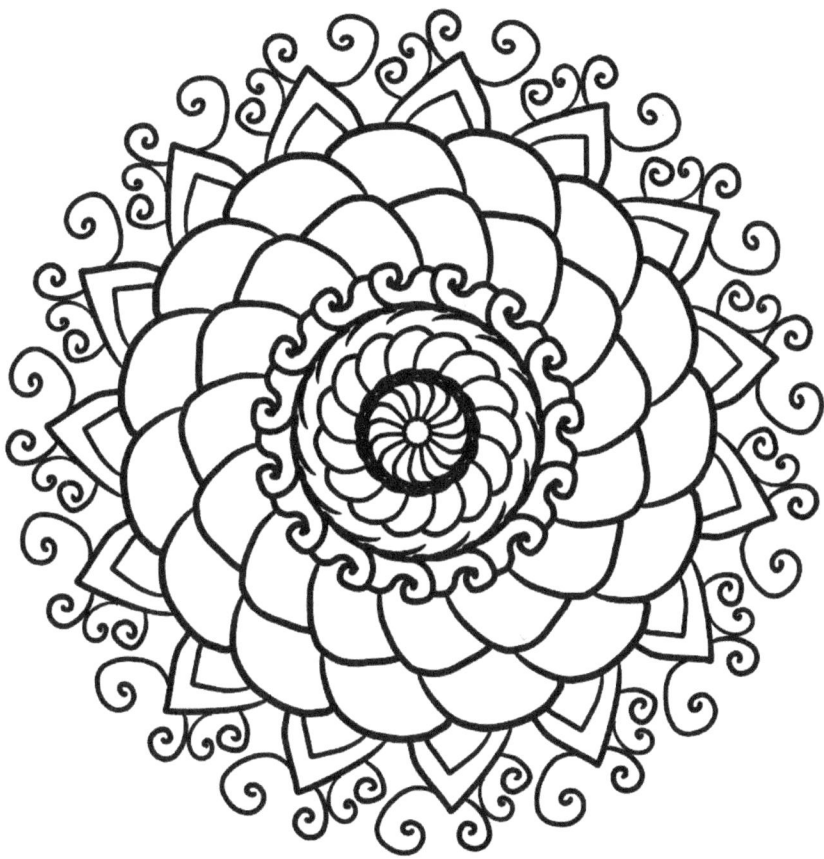

Release

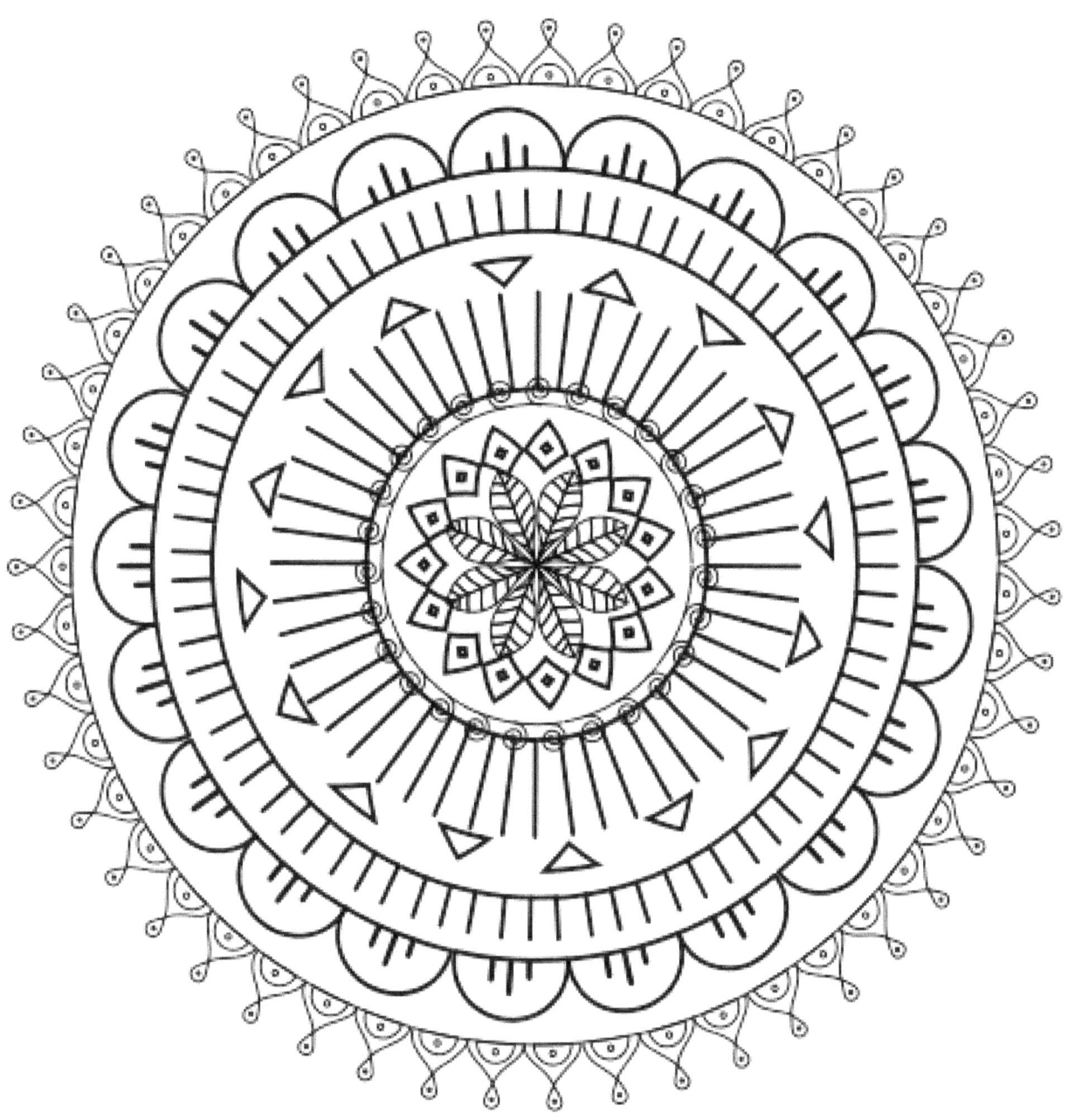

LOUISE ATHERTON

COLOR MY MANDALAS

www.ingramcontent.com/pod-product-compliance
Lightning Source LLC
Chambersburg PA
CBHW081253180526
45170CB00007B/2410